Saratoga Favorites

Mae & Shawn Banner

Dedication

This Book and the show it commemorates are dedicated to Mae Banner. She has fostered two generations of dance lovers and word mavens. We think of her often, whether sitting under the July stars at SPAC, enjoying the lawns at Jacob's Pillow, taking in Shakespeare in Congress Park, or simply enjoying a good bedtime story. The woman certainly knew how to turn a phrase, and put that skill to fine use.

So, a tip of the proverbial Saratoga Hat to Mae, much beloved and always remembered.

Acknowledgments

Many thanks to Mary Anne Fantauzzi, a great friend of my mother and myself, for conceiving of and helping to curate "Saratoga Favorites, Mae & Shawn Banner", as well as for her help in the selection and editing of much of the text presented in the exhibit. Mary Anne, a major force for Dance in the Capital Region, is deservedly loved by the dancers of the NYCB and her local compatriots, and continues to inspire us all.

Additional thanks to Laura DiRado for her unerring eye and consummate skill in designing and mounting this exhibition. My drawings have never looked so good!

And of course, thanks to Susan Edwards and the National Museum of Dance for bringing this exhibit to fruition.

<div style="text-align: right;">S.B.</div>

Saratoga Favorites

Mae & Shawn Banner

Saratoga Springs has been privileged to be the Summer Home of the New York City Ballet these last 50 summers. For more than 25 years of their residency, Mae Banner captured in words the joy and wonder of what we all saw on stage. And, for nearly as long, her son, Shawn Banner, has been capturing in fluid line this shared vision.

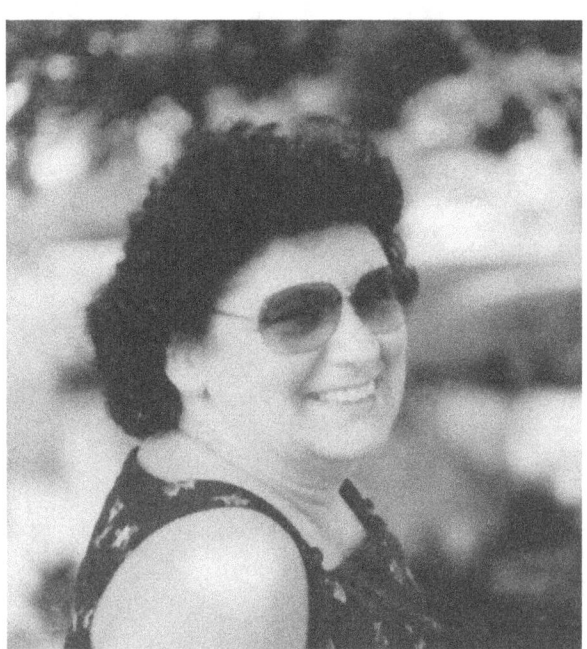

Mae Banner felt deeply the importance of documenting the NYCB's summer residency at SPAC, and so began a quarter century career writing ballet reviews for *The Saratogian* and *Metroland*, becoming the definitive voice for the ballet's many admirers.

When Ms. Banner and other members of the Dance Alliance first developed *Ballet Beat* to further promote and illuminate the NYCB's annual summer residency, she invited me, her son, to draw for the project. Thus began my long tenure as *Ballet Beat's* resident illustrator. The illustrations shown here, a sampling of 20 years of drawing for *Ballet Beat,* along with excerpts from Mae Banner's reviews, highlight some of Saratoga's favorite New York City Ballet works.

Illustrator, Shawn Banner

Artist, Illustrator, and Educator, Shawn Banner began his professional illustration career 30 years ago, working in New York City as a fashion illustrator. He expanded his oeuvre to include general illustration for a variety of clients in the fields of advertising, editorial, and book illustration. The dance illustrations in this show represent 20 years of illustrating for *Ballet Beat,* which has included Mr. Banner's work since its inception. Mr. Banner's love of art and dance was fostered by his parents and nurtured during his time at Oberlin College, FIT, and his years working at SPAC, as well as at SUNY Purchase and the Joyce Theater. Like his mother, Mr. Banner has always appreciated how truly fortunate he is to be in Saratoga and to enjoy the New York City Ballet in this, their summer home.

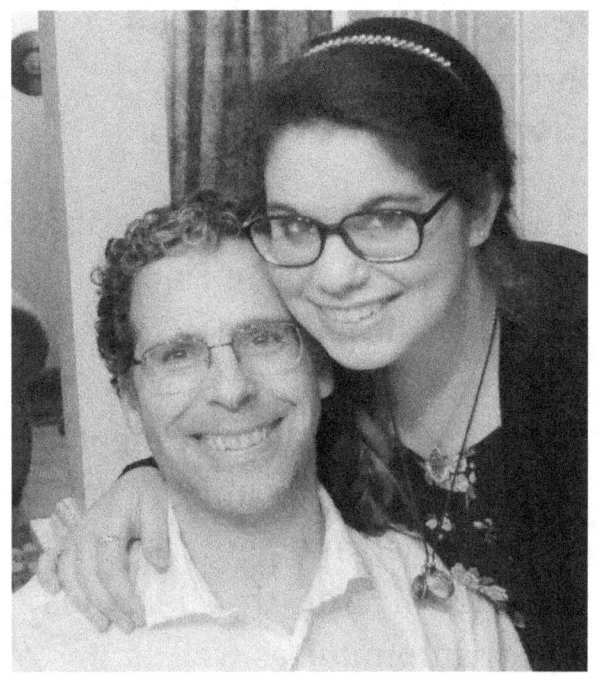

Rosalie began attending ballet performances with her grandmother when she was a pre-schooler, and has continued to be a ballet fan ever since. (In those earliest days, a part of the appeal was the stash of fancy hard candies my mom kept in her performance bag--my kids still remember those fondly--but even without the candy, the ballet is still a sweet experience for us both!) Rosalie's first ballet was Midsummer Night's Dream, a perennial family favorite.

'Coppelia' is a Magical Evening of Dance (Saratogian, July 2003)

"Sugar and spice. That describes the dancing of Megan Fairchild in Coppelia, the pastoral-comical ballet performed by the New York City Ballet Tuesday night at the Saratoga Performing Arts Center. Crisp and petite, she held the stage in a role that demands clear pantomime as well as strong technique. By turns, Fairchild could be demure in delicately placed steps on point. Or, she could be quite the soubrette, flicking a disdainful leg to scold her fiancé, Frantz, for pining over Coppelia, the silent beauty who sits reading on the upstairs balcony of the dollmaker, Dr. Coppelius."

My First Ballet Illustration

"My first summer working at SPAC, my friend Lori Liebert had the job of collecting autographed toe-shoes to sell at the gift shop. Like the rest of Saratoga, I was totally enthralled with Patricia McBride, (Saratoga's very own Coppelia), so Lori got me a pair of her shoes. I drew a thank-you card, a ballerina in arabesque, which Lori promised to give to Ms. McBride on my behalf. After the matinee, as I was leaving through the performer's gate, I saw her, our Patti, leaning against the gate post, awaiting her ride, languidly fanning herself with my card. Of course, shy pup that I was, I didn't have the nerve to go up and introduce myself, but I still carry that image of her in my mind. And I still have those toe shoes. And they still smell of rose water....."

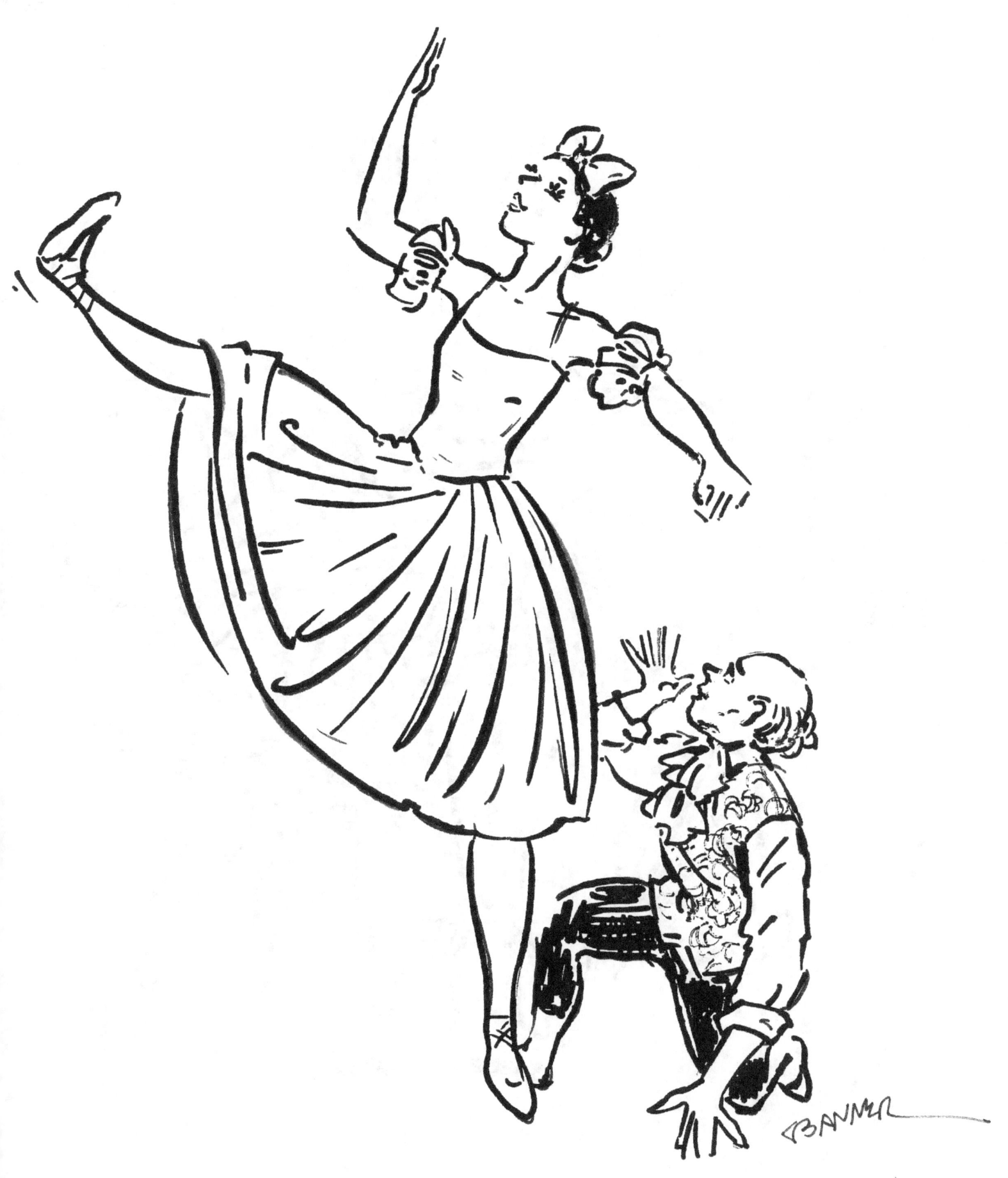

Doll's Dance from Coppelia

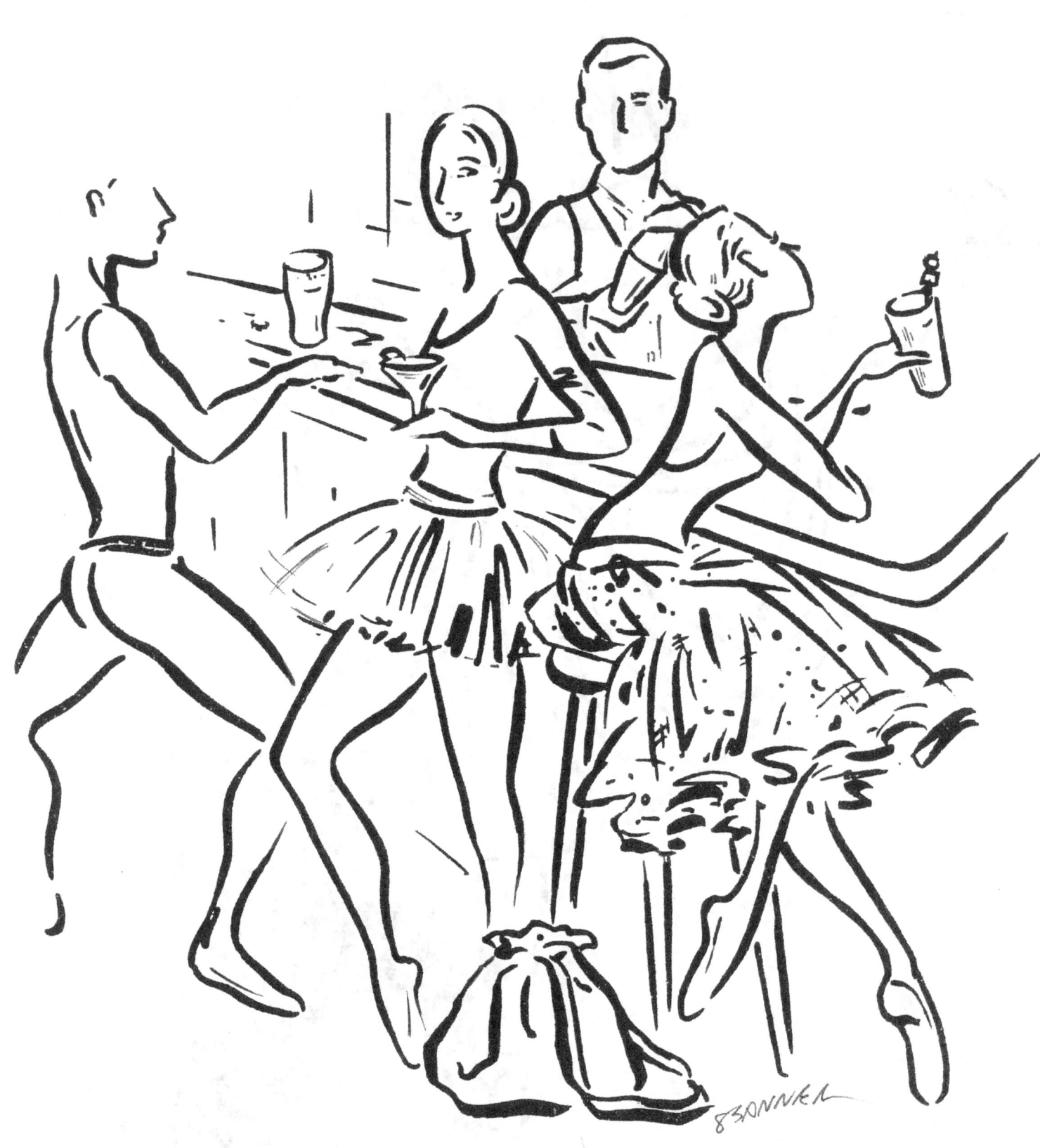

Dancers at the Bar

Dance Reviewer, Mae Banner

Moved To Words:
A Passion for Dance Fuels One Critic's Quest to Portray and Preserve the Most Fleeting of Art Forms
(Metroland, June 2001)

"I didn't know it, but I'd been training to be a dance writer for about five years before I wrote my first review, a few paragraphs on Albany Berkshire Ballet's Nutcracker that ran in 1984 in The *Saratogian*.

It was rigorous training, self-imposed. My son had bought me a small blank book, part calendar, part journal, called Dancing Times. About the size of a palm pilot, it was designed to keep track of the dates and times of dance concerts, but with extra space for recording one's impressions of the performance. It was the perfect gift for a balletomane, which is how I'd learned to define myself almost from the first time I saw the New York City Ballet dance A Midsummer Night's Dream at Saratoga Performing Arts Center.

Understand I'd never had a ballet lesson, nor even seen ballet as a kid in Detroit, though my parents did take me to the theater and to free summer concerts at the outdoor band shell on Belle Isle, the huge park. In high school, I took modern dance, but it was more like calisthenics than art. In college, I joined the modern dance club and got to perform, first as a villager doing a hora-like line dance, and then as onstage narrator for dances set to a psalm and a poem from Winnie-the-Pooh. Exciting, but not enough to transform an English major into a balletomane or a dance writer. Both of those happened decades later in Saratoga.

Besotted by my first encounter with ballet, I would go to see City Ballet every night of the summer

season, five nights a week, either as an usher or using the usher passes we got as volunteers. Every night, after the last curtain call, I would rush to the Adelphi Hotel, where I'd jostle with the rest of the groupies for a table on the back porch. My favorite spot was between the barroom and the backyard, because everyone – dancers, fans and wannabes – had to pass through that narrow aisle as they came and went.

Once I got settled, I'd order a kir, pull out my pen and my Dancing Times, and write nonstop until the passion was spent. Of course, I'd already filled the margins of my program notes: "Bobby Maiorano rolls his shoulder in 'Dances at a Gathering'- breathtaking"; "Lourdes Lopez, one of the four baby swans, but dancing larger than the others – watch her progress"; "Bart Cook's fluid back in 'Four Temperaments' – so deeply arched, it's as if he's being pulled offstage by a magnet."

These notes became the jumping-off place for fuller, sharper descriptions of form and feeling that I wrote in my pocket journal, not because I ever expected to be a dance critic, but simply to grab and hold onto the performance while it was hot. Writing was both a way to cool down and to remember.

When I started writing dance reviews for real, there were no more curtain calls, and there was no time for the Adelphi. At the first applause, I ran for the SPAC parking lot and rushed to the paper to make the deadline. Most nights, I had about 45 minutes to get it down. That, too, was good training. I found that if I could resist clichés, I could explode on the page.

Writing about dance is an act of love and also an act of salvaging. Among the performing arts, dance is the least seen and the soonest gone. As such, dance cries out to be documented, to be saved from current invisibility and future oblivion.

My writing is an attempt to tether this fly-away art, to give readers something to hold onto, and to help the dance audience grow in every sense of the word.

Oh, and whether or not I'm on assignment, I still scribble all over the margins of my program."

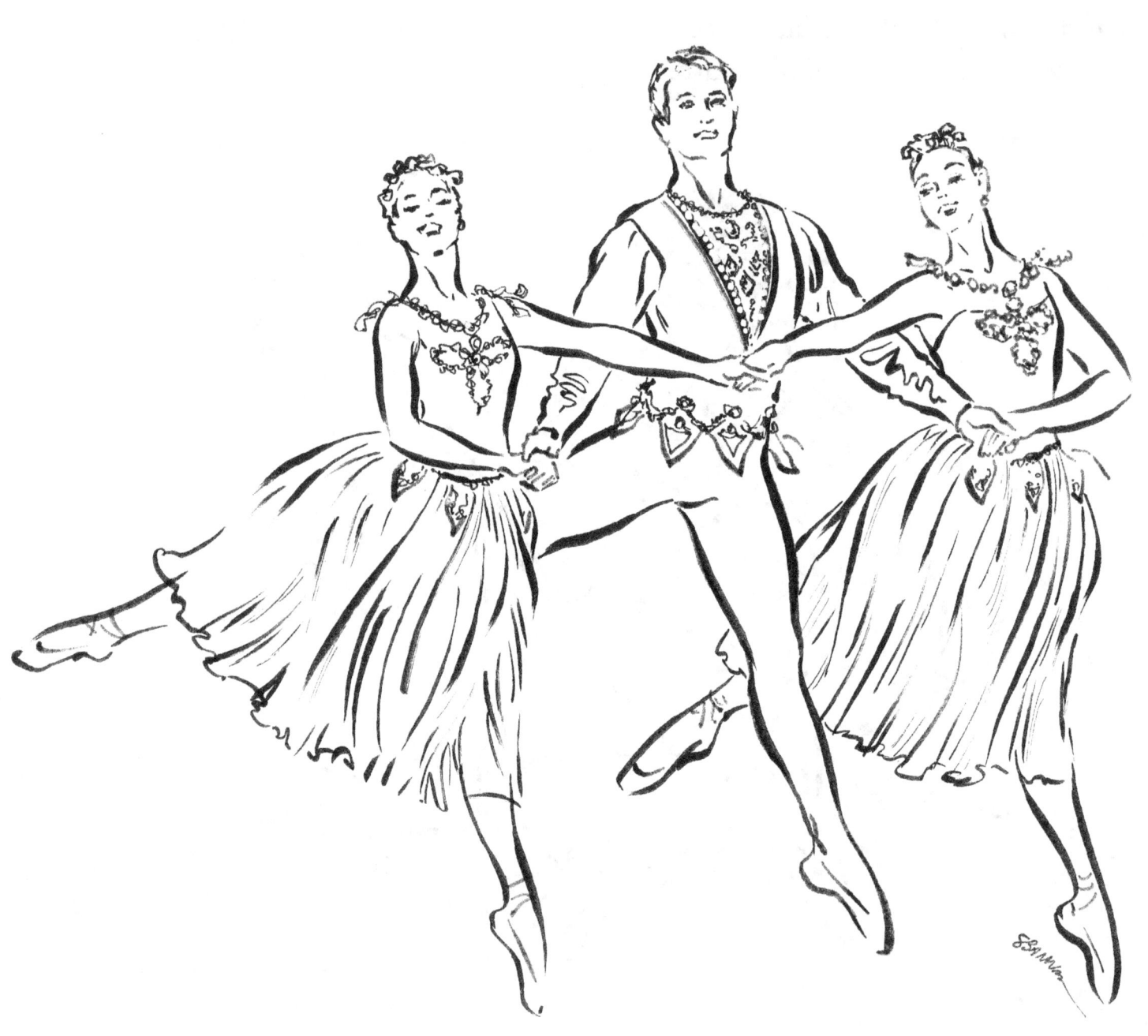

Emerald Trio from Jewels

'Jewels' Dazzles Audience Despite a Few Flaws
(Saratogian, July 2004)

"Jewels is back more dazzling than ever. Corps member Teresa Reichlen, as a bold showgirl, stole the limelight….in Rubies set to Stravinsky's syncopated music. Reichlen, who joined the corps in 2001, magnetized Rubies. All eyes were riveted on this tall fearless Broadway baby who seemed to lead four men around by their noses. They worshipped her but, they could never hold onto her. Her final pin-up pose, proud and confident, is the hot-unattainable gal we dream about."

"Emeralds might be set in a glade at Monet's garden in Giverny. The deep green-blue backdrop is a lush watercolor. The dancing is lush, too. The two women's solos, full of giddy spins, and calligraphic curving arms, speak of content or joy. Arms enfold the air as if they were gathering up piles of cashmere shawls. Feet make effervescent little runs, like pouring champagne. The partnering – James Fayette with (Jenifer) Ringer, Robert Tewsley with (Miranda) Weese, is temperate, serene (except that the feral Fayette, for all his princely demeanor, radiates an inner heat). Even the full cast finale, with a supporting trio and a corps of ten women, is stately, symmetrical, posed in sculptural tableaus with a French sense of order. After the concluding promenade, the women stand calmly. The men kneel raising their arms in admiration."

"Diamonds was a promise fulfilled. More than regal, the dancing was empyrean. Sparkling jewels hang in asymmetrical clusters. Everyone is in blinding white and all the women wear flashing tiaras. Diamonds could be a ballet in a movie or in one's most vivid dream. The choreography is purely classical, the essence of Petipa. Wendy Whelan is icy fire, commanding the stage with her long legs and perfect placement. She spins onstage and jetes out, magnificently. The final, extravagant Polonnaise brings out the full corps of a dozen couples ….The sumptuous image grows and grows as the orchestra reaches a climactic crescendo."

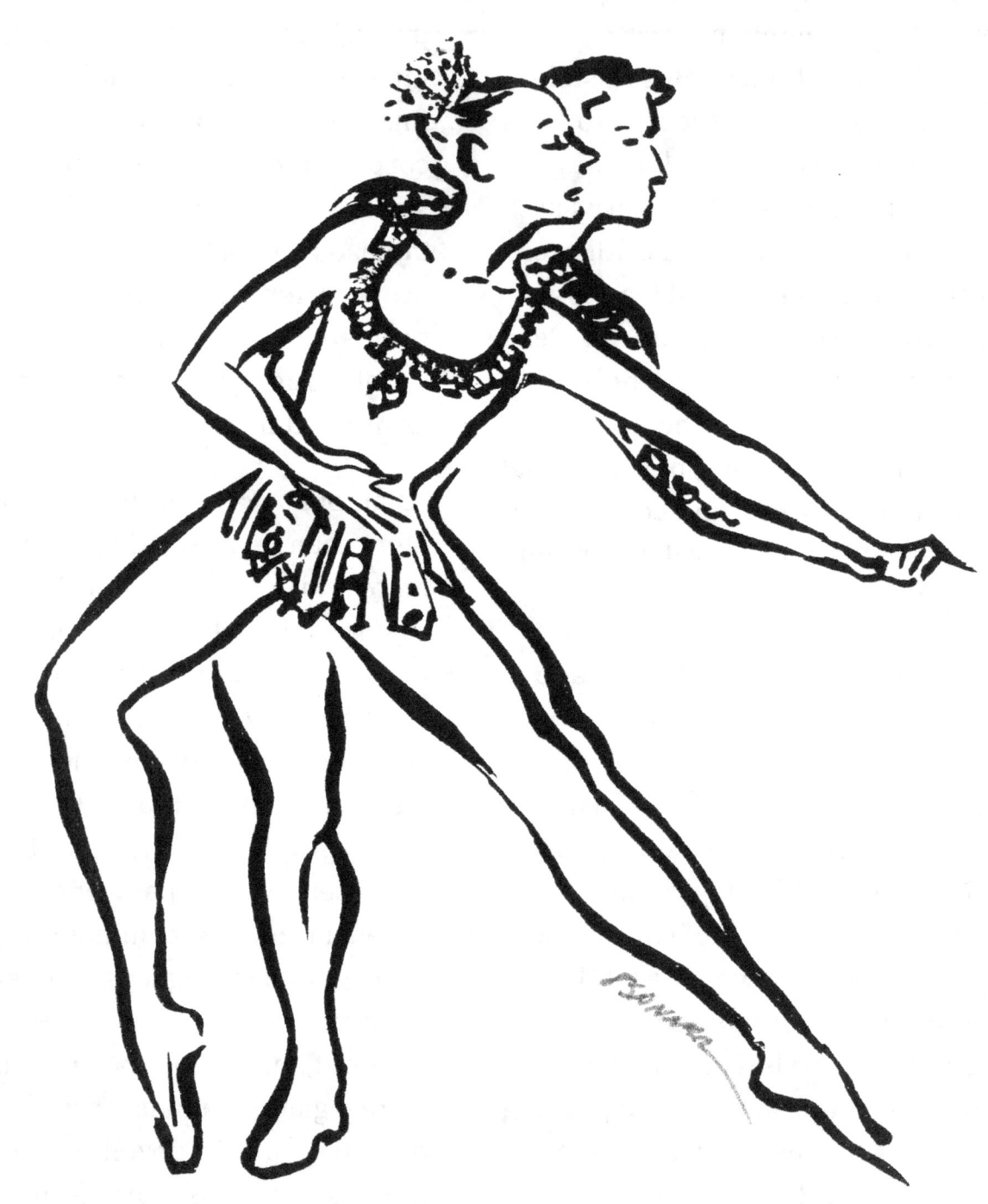

Ruby Duet from Jewels

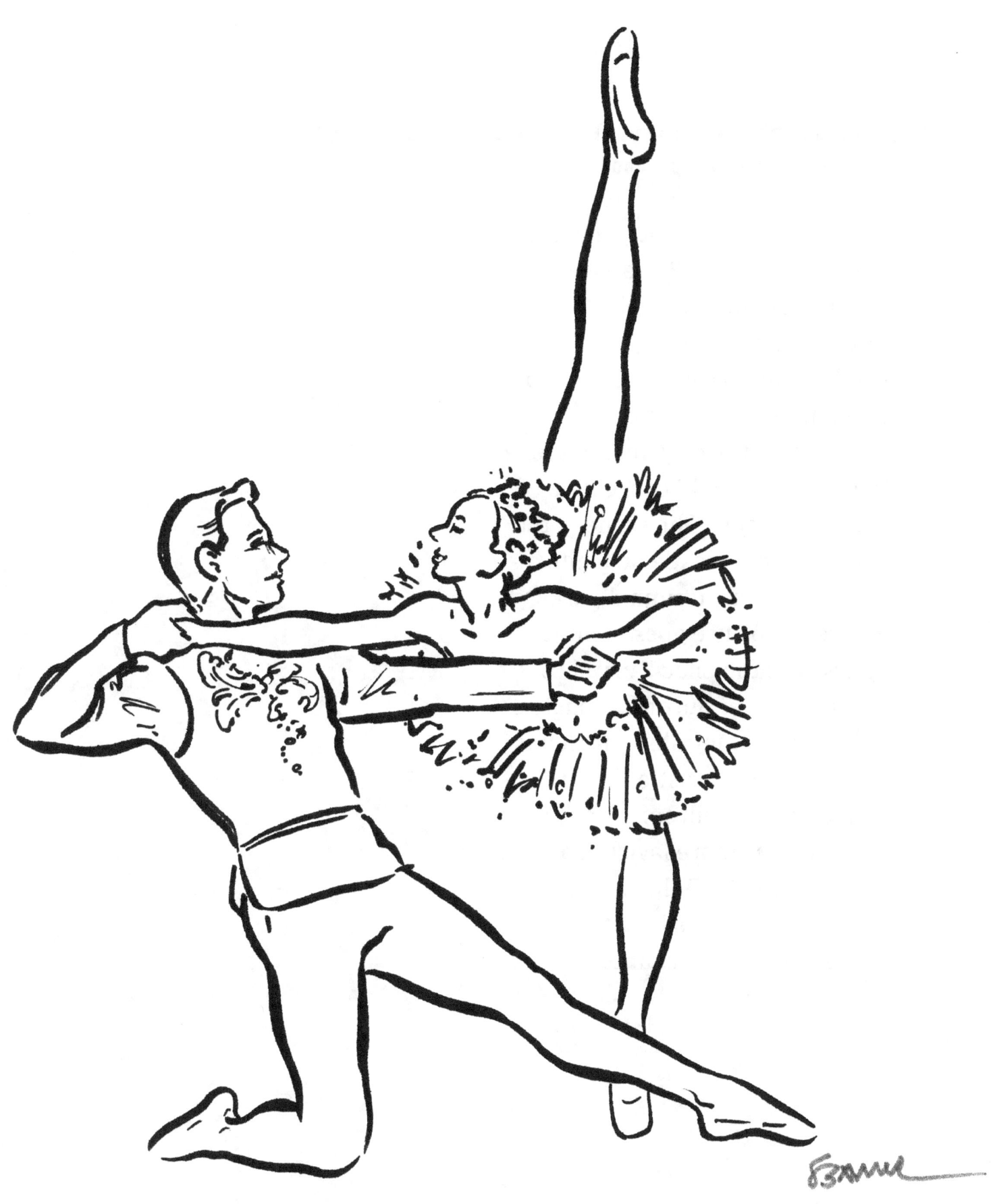

Diamond Duet from Jewels

Morals of the Story: 'The Sleeping Beauty' (Metroland, July 2000)

"...The Sleeping Beauty, Martins' ballet, made in 1991, is eye-filling, stage-filling, and ultimately enchanting. The production is rich in color, from the parade of silk-caped courtiers in the christening scene to the radiant gold of the final wedding scene. The scenery, too – a watercolor castle on a hill; a golden-brown autumnal park where the prince goes to hunt, and where the Lilac Fairy shows him a vision of Aurora; a magical bejeweled sailing ship that leads him to Aurora's castle; a grand chandeliered ballroom for the wedding – is more lavish than anything in City Ballet's book. Just looking at this ballet is an invitation to be enchanted."

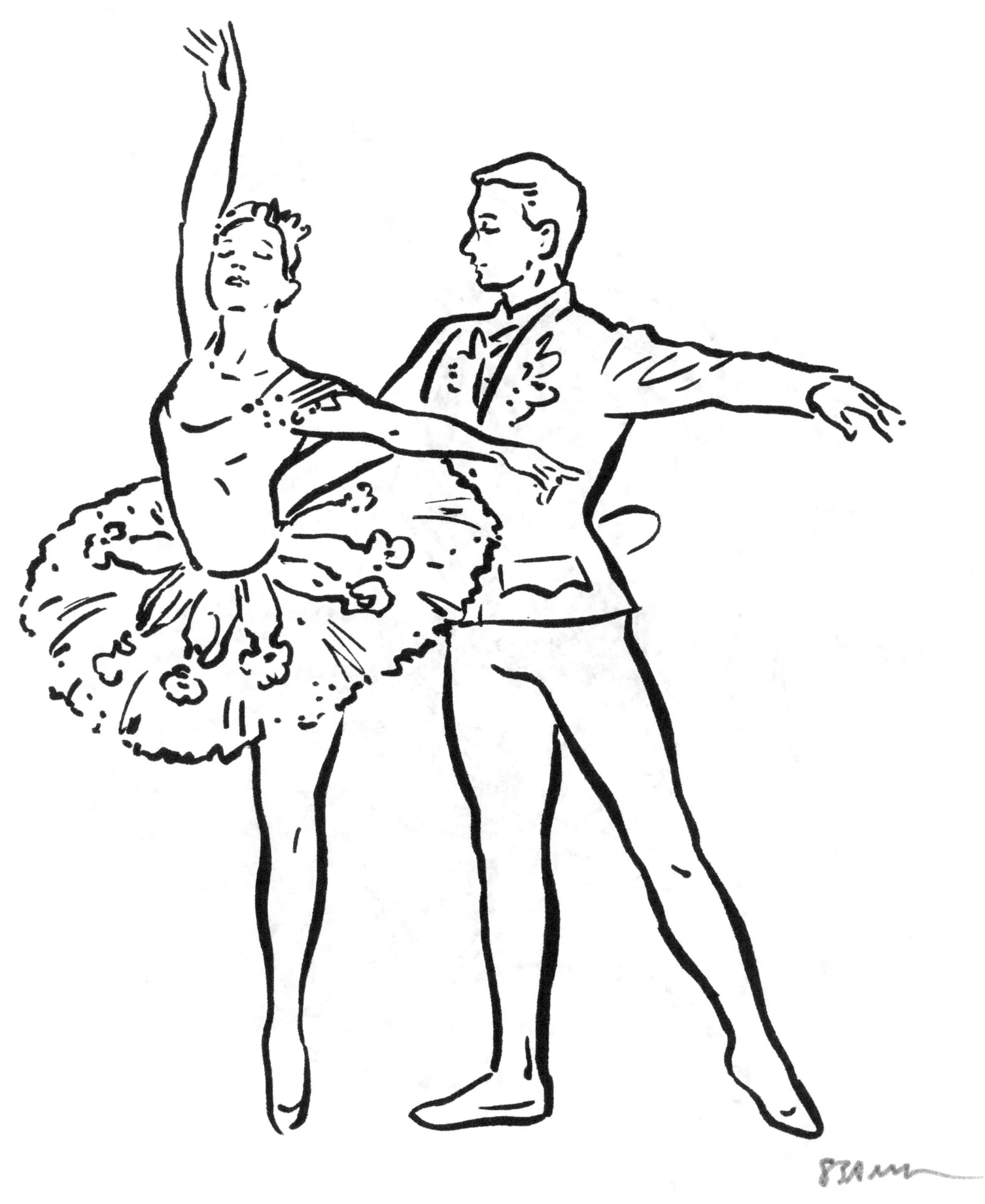

Duet From Sleeping Beauty

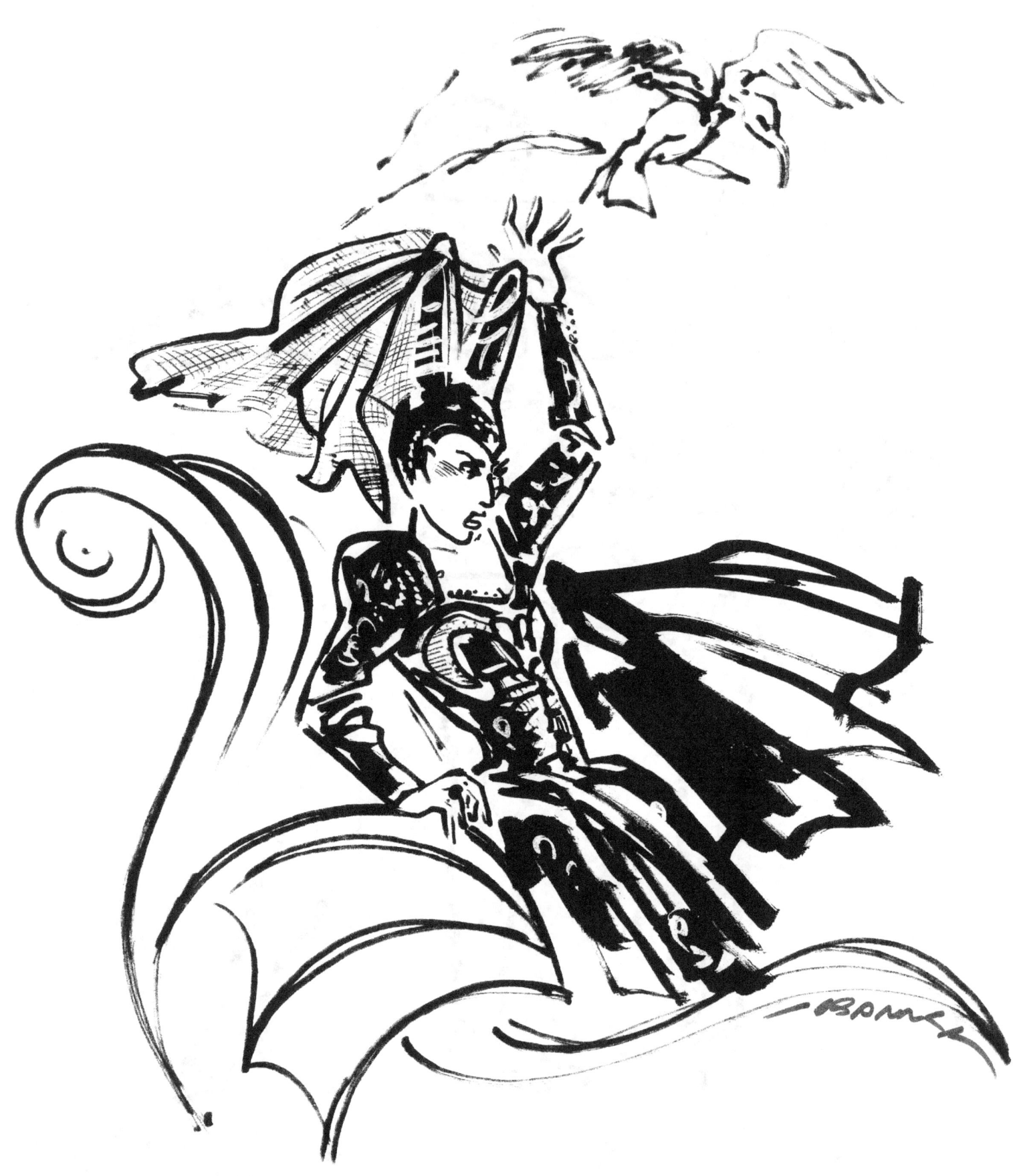

Carabosse

Morals of the Story: 'The Sleeping Beauty' (Metroland, July 2000)

"Like Greek gods and goddesses controlling the fate of mortals, Carabosse and the Lilac Fairy preside over the action, contending throughout in a battle of good and evil...the whole trouble starts because the parents of the newborn princess forgot to invite the fairy Carabosse to the christening. The black-gowned Carabosse, eyes flashing, fingernails out to there, is really, really mad. She shows it by casting a spell on the baby, dooming her to die on her 16th birthday from pricking her finger on a spindle. Only the gentle power of the Lilac Fairy saves Princess Aurora, transforming death into a hundred-year sleep that will end when the prince comes to awaken her. So, is the moral of the tale: 'Check your guest list carefully, or woe betide you?'"

NYC Ballet off to an Enchanting Start at SPAC (Metroland, July 2003)

"The New York City Ballet opened its 38th season at SPAC on July 8 with the perfect outdoor ballet, George Balanchine's A Midsummer Night's Dream. Based on Shakespeare's comedy of confusions in an enchanted forest, and set to Mendelssohn's music, the firefly-lit dance fits SPAC's open-air theater like a silken glove. As Pucks fly, it was a toss-up between Albert Evans, a cheeky sprite who danced in cahoots with the audience, and newcomer Daniel Ulbricht, who excelled in speed in stratospheric jumps. All ends well when Puck takes up his broom to sweep the dust from out the door - and then, he soars."

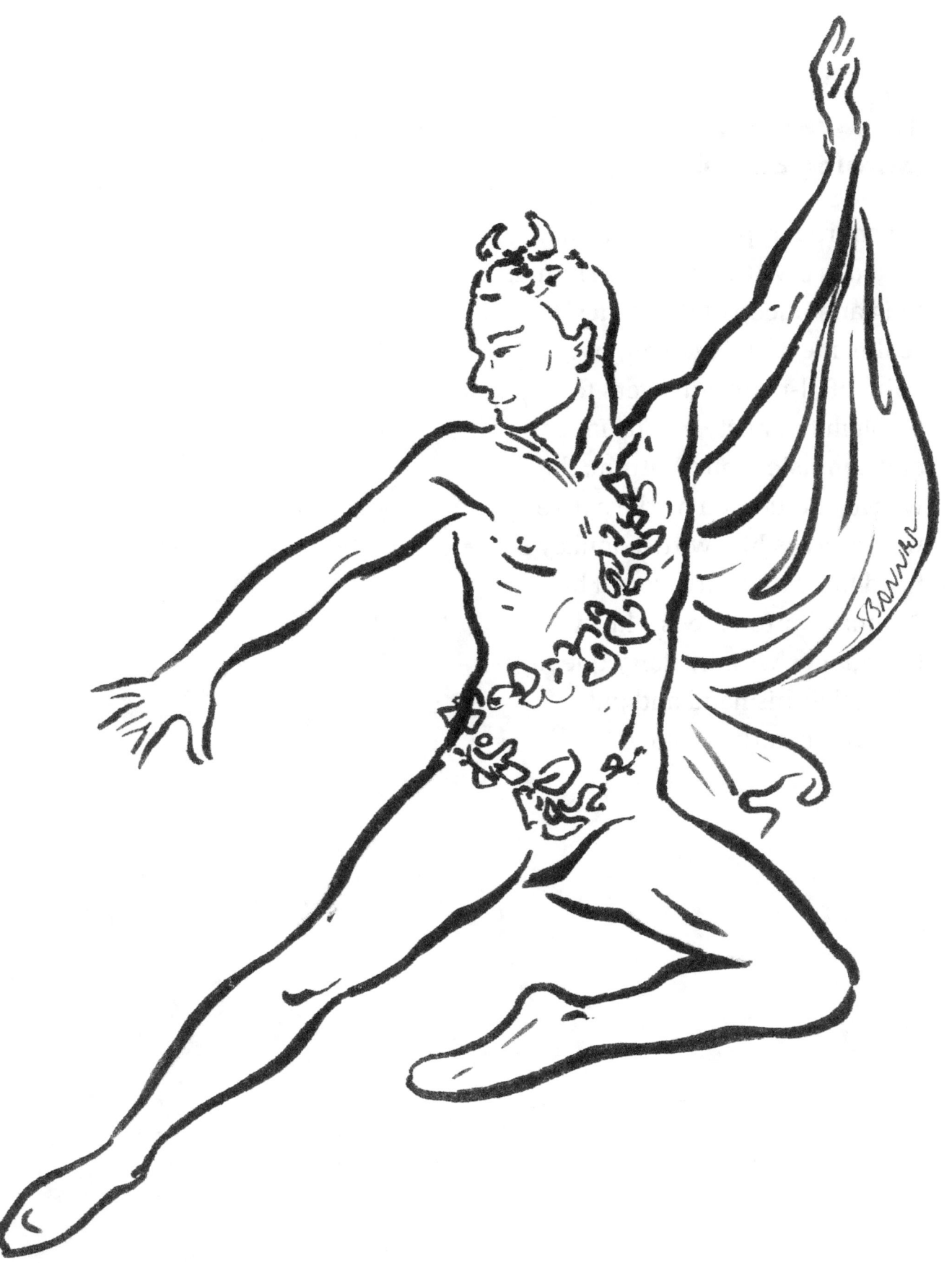

Puck Soars

**Relive the Dream
(Saratogian, July 2003)**

"In choreography true as a well-aimed arrow, Oberon and Titania, king and queen of the fairies' realm, meet and quarrel; two pairs of ill-matched lovers fly through the misty woods in fear and confusion; and Bottom, the weaver, befuddled by the sprite who crowns him with a donkey's head finds himself beloved by Titania. Bottom does a kicky little dance with the fairy queen, who takes his hand and pulls him, reluctantly, offstage."

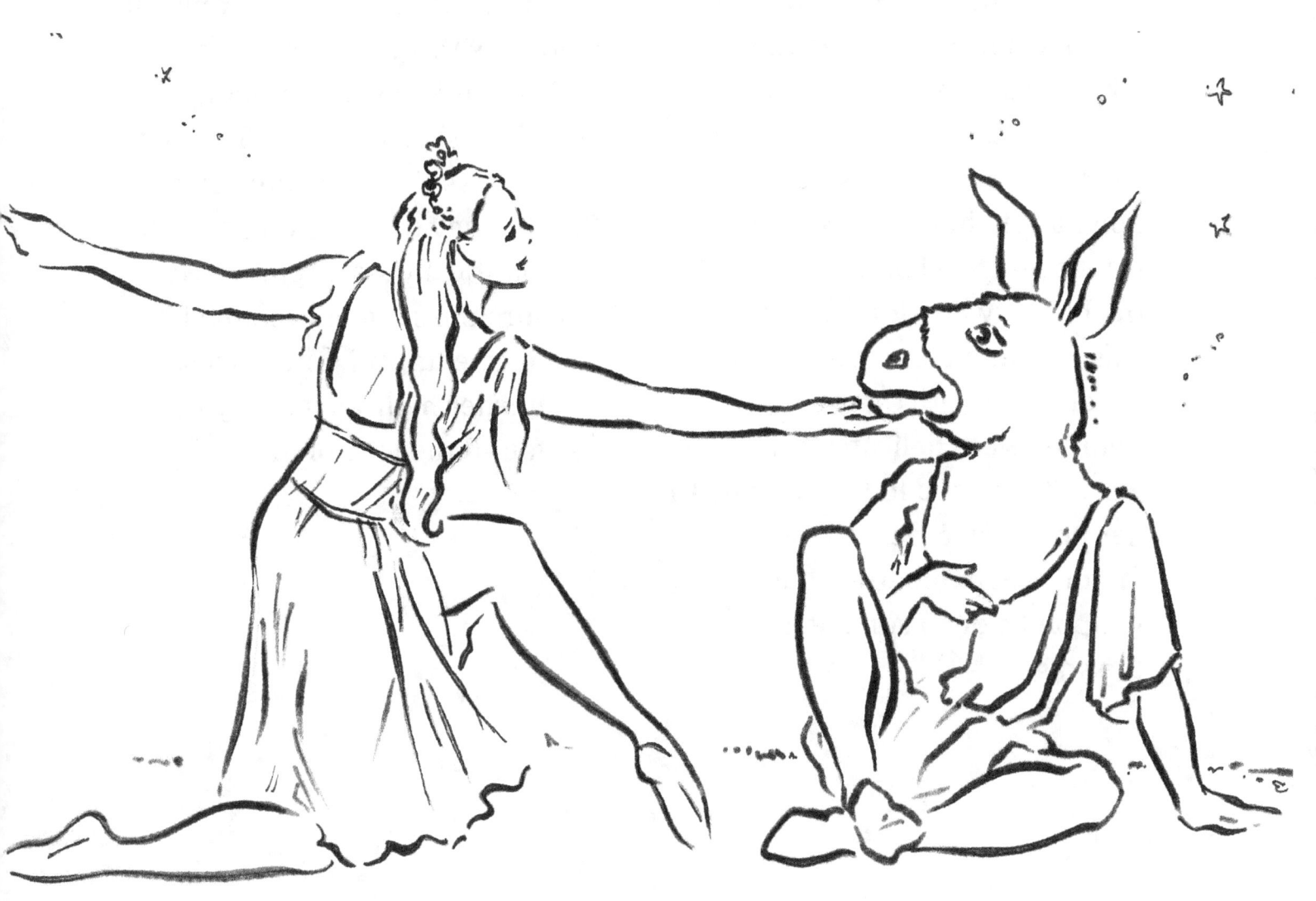
Bottom and Titania

NYCB's Divine Dance of 'Swan Lake' not to be Missed
(Saratogian, July 2003)

"Maria Kowroski….ruled the stage Wednesday in the double role of Odette/Odile. As the white swan, she was proud, with big, bold extensions, magnificent even in her fearfulness, and poignant in her sorrow when prince Siegfried betrayed her. As the black swan, Odile, Kowroski was cold, dangerous, a seductive deceiver. Where Odette's bourees were delicate, Odile's were strong and led unerringly to her powerful execution of the famous set of fouettes that whipped a deep current across the stage.

Philip Neal…was a complex Siegfried. He conveyed a range of emotions through pure dance and gesture, never overacting and always clear. When Siegfried encounters the enchanted swan, Odette, they dance a long duet at a romantically slow tempo. Neal devours the stage in a solo with side leg beats and jump turns. He lifts her high, as if to say he has found the love of his life."

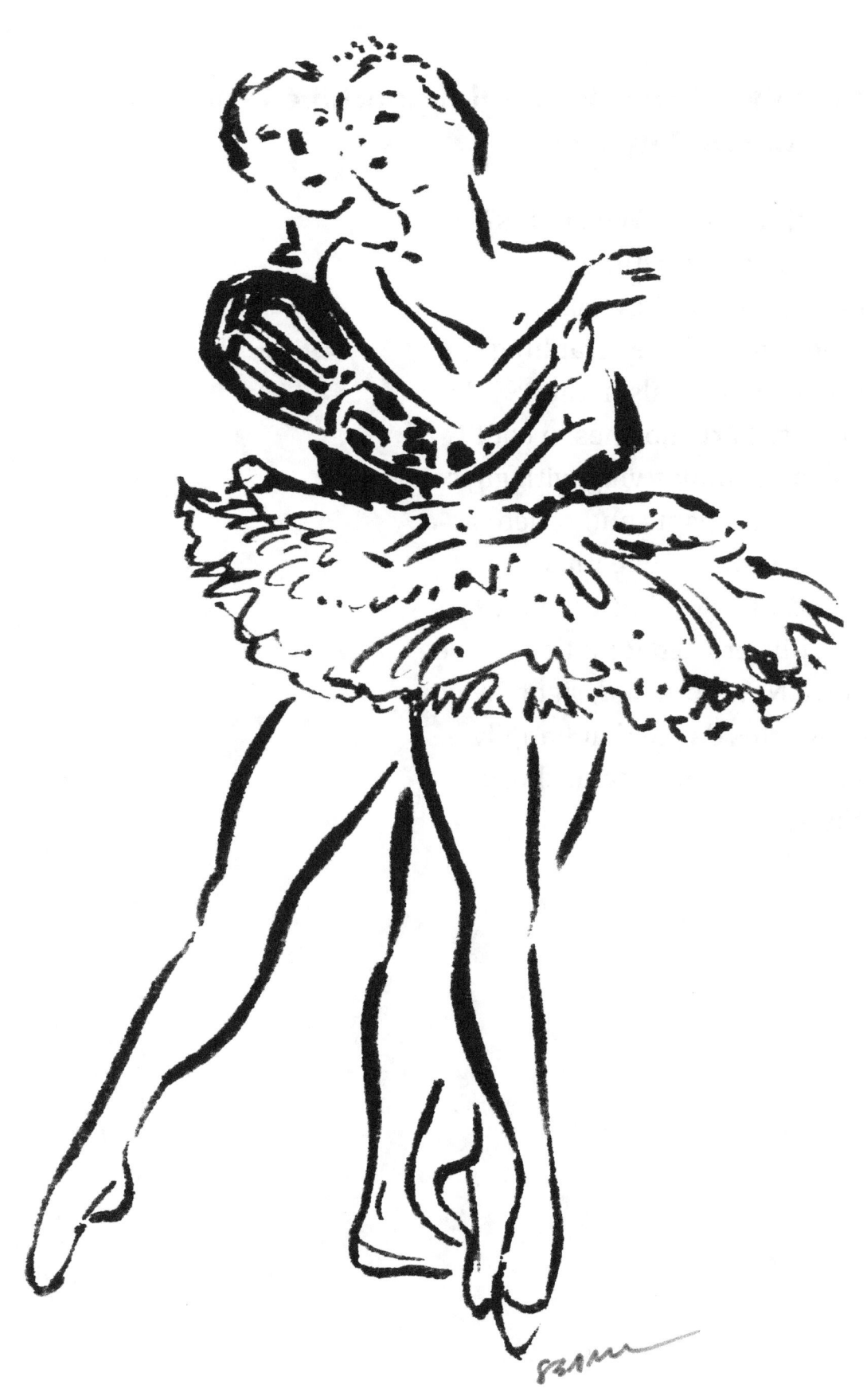

Duet from Swan Lake

NYC Ballet Opens With All-Balanchine Program (Saratogian, July 2002)

"A dazzling closer, Who Cares?, is packed with everything Balanchine, the showman, learned from choreographing Broadway musicals in the 1930's and 40's. Pert chorines in cool blue or hot pink swing with guys in gray satin pants and rolled sleeves, jazzing beneath a splayed-out New York skyline that's pin-pricked with lights. We all love New York and, right away, we love this dance that happily mixes pas du chats with chorus kicksteps."

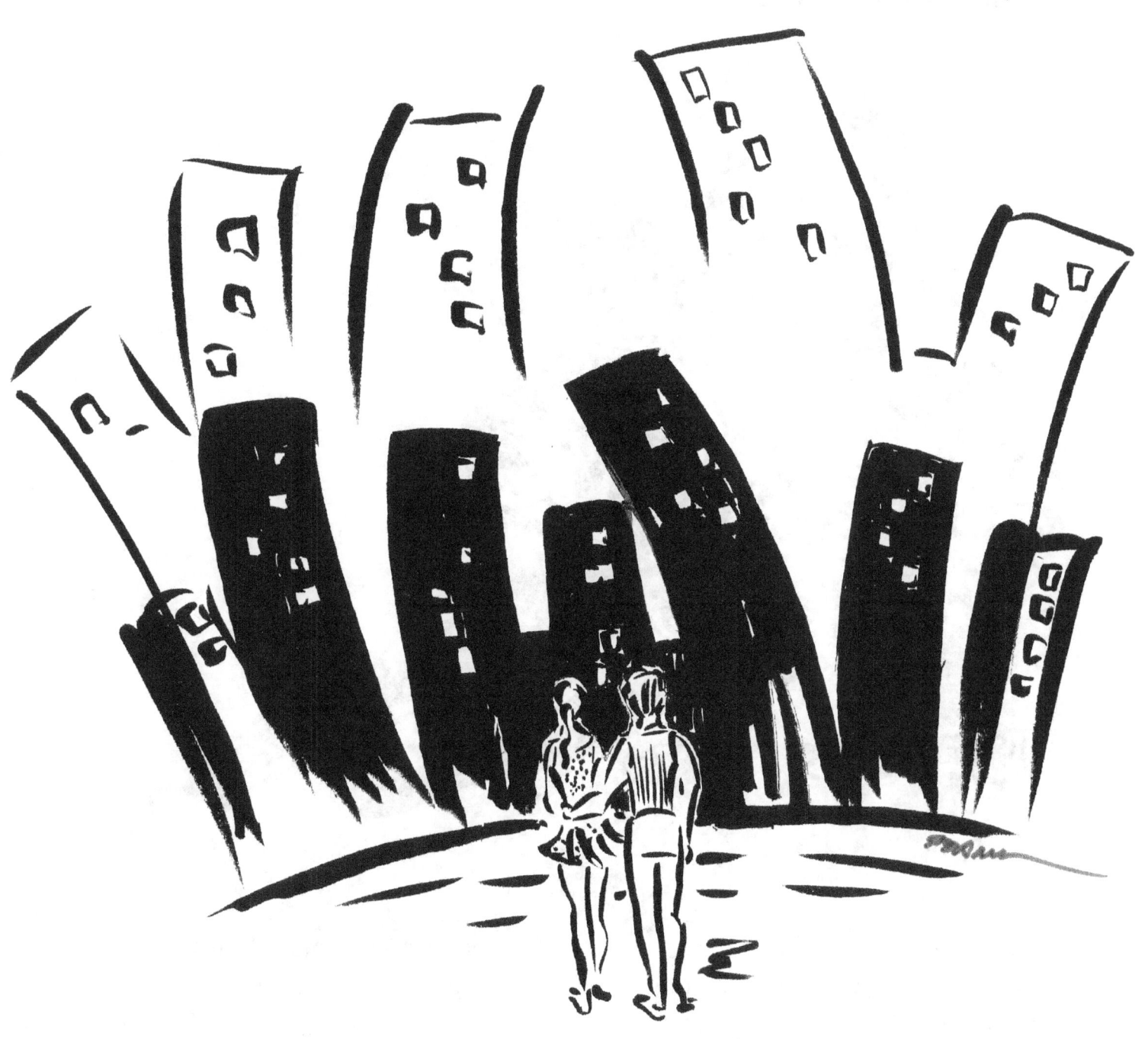

Manhattan Jive, Who Cares!

**Trio of ballets shows off NYCB's versatility
(Saratogian, July 2003)**

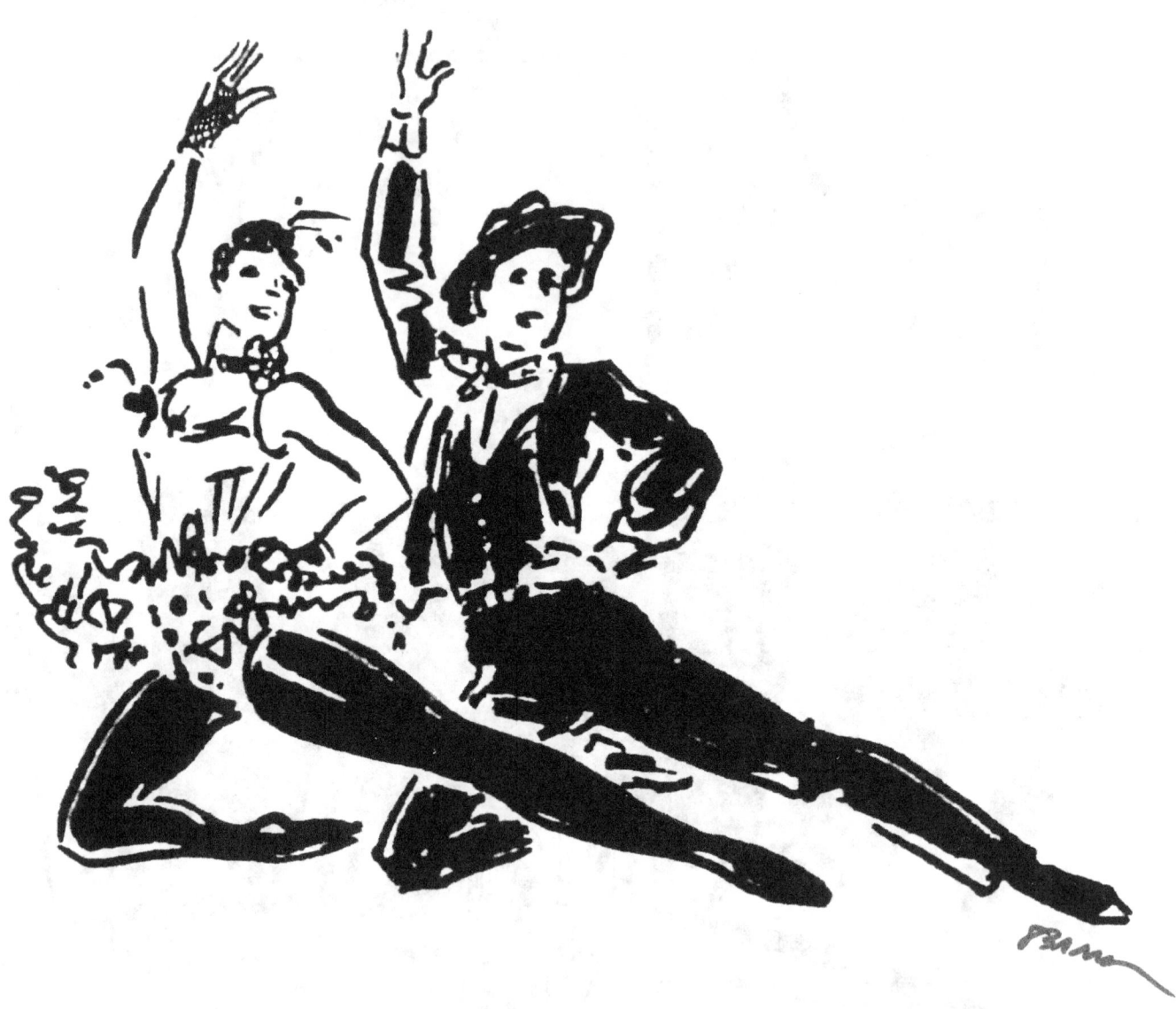

"The floradora girls and cowpokes in Western Symphony (1954) are…stereotypes, but, the ballet works because it's all tongue and cheek. It's also incredibly demanding, full of high jumps and kicks that bring a ballerina's toes to her nose. The leading couples, Jennie Somogyi with Nilas Martins; vibrant Janie Taylor with Albert Evans; and the queen of long legs, Maria Kowroski with Charles Askegard, kicked up considerable dust, whirling into a great, colorful finish."

'Guide to Strange Places' Opens at SPAC with Thunderous Fervor (Saratogian, July 2003)

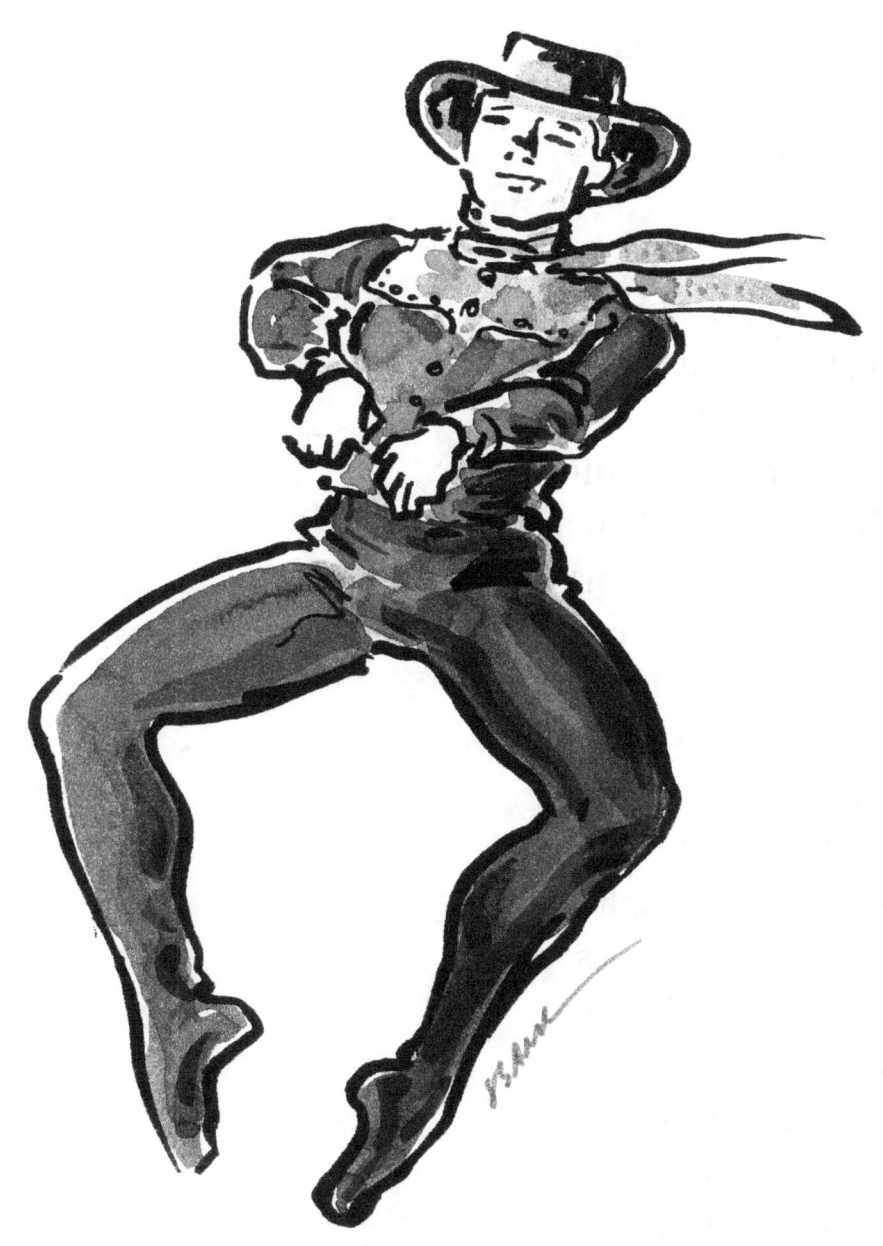

"The Western movie set backdrop and spiffy costumes by Karinska – showgal ruffles and plumes for the women and black wranglers' outfits for the men – looked newly minted."

I'm Old Fashioned

"The audience always applauds when Fred Astaire's name appears on the giant movie screen that serves as a backdrop for Jerome Robbins' I'm Old Fashioned.

The ballroom ballet is a knowing, loving homage to Astaire, whom Balanchine and Baryshnikov have praised as a model. (Philip) Neal and (Maria) Kowroski made a small drama of the New York skyline scene. She dances off with Sebastien Marcovici, leaving Neal alone in the midnight city. He turns smoothly this way and that, yearning toward the spot where she stood, then toughing it out on his own. He even does a couple of 'kick your heels in the air' jumps to show he's not defeated. Ah, but Kowroski comes back, flying into his arms in that coral red gown, so all's right with the world."

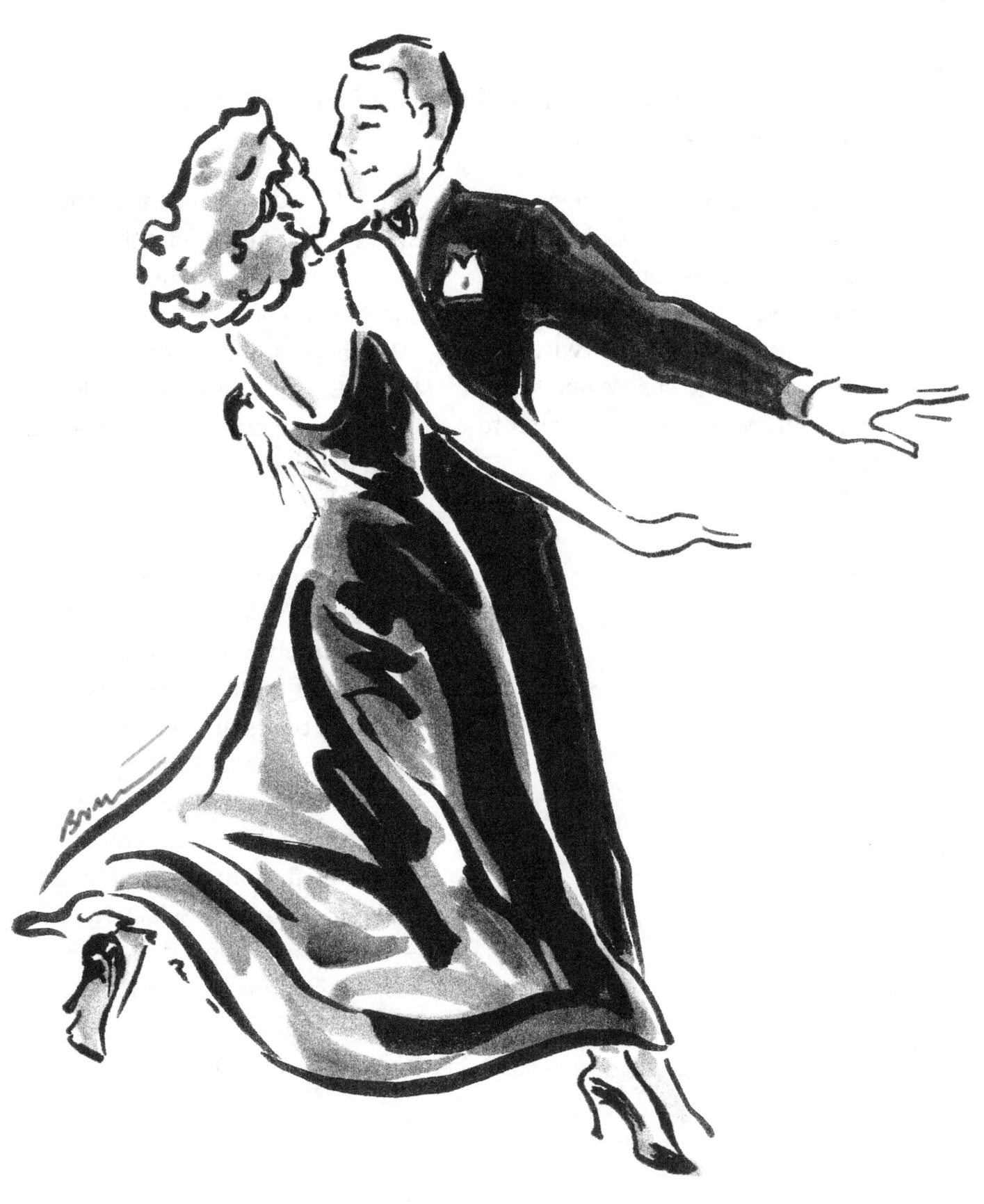

In Our Hearts, We Are All Old Fashioned

Waltzes Added to a Magical Night of Beautiful Ballet (Saratogian, July 2006)

"Nikolaj Hubbe was an eager cavalier to a teasing Rachel Rutherford in the opening woodsy scene, all arched back and clicking heels as he twirled her among the trees. When the party ended, the forest was left to its rightful inhabitants."

When I used to drive my mom to SPAC, she would insist that we take the Avenue of Pines both coming and going. It was an integral part of her Summer Ballet Experience and her night would feel incomplete without it. We'd drive with the windows rolled down, enjoying the heady scent of the pines arching over head and, on the return trip, the car lights sparkling through their trunks and branches. The second movement of Vienna Waltzes captures that same feeling...and then, when the trees rise up, their roots transforming into chandeliers that flash into sparkling illumination, the whole audience shares a collective gasp—theater at its best and it never fails to enchant us. Vienna Waltzes will always be a perennial favorite.

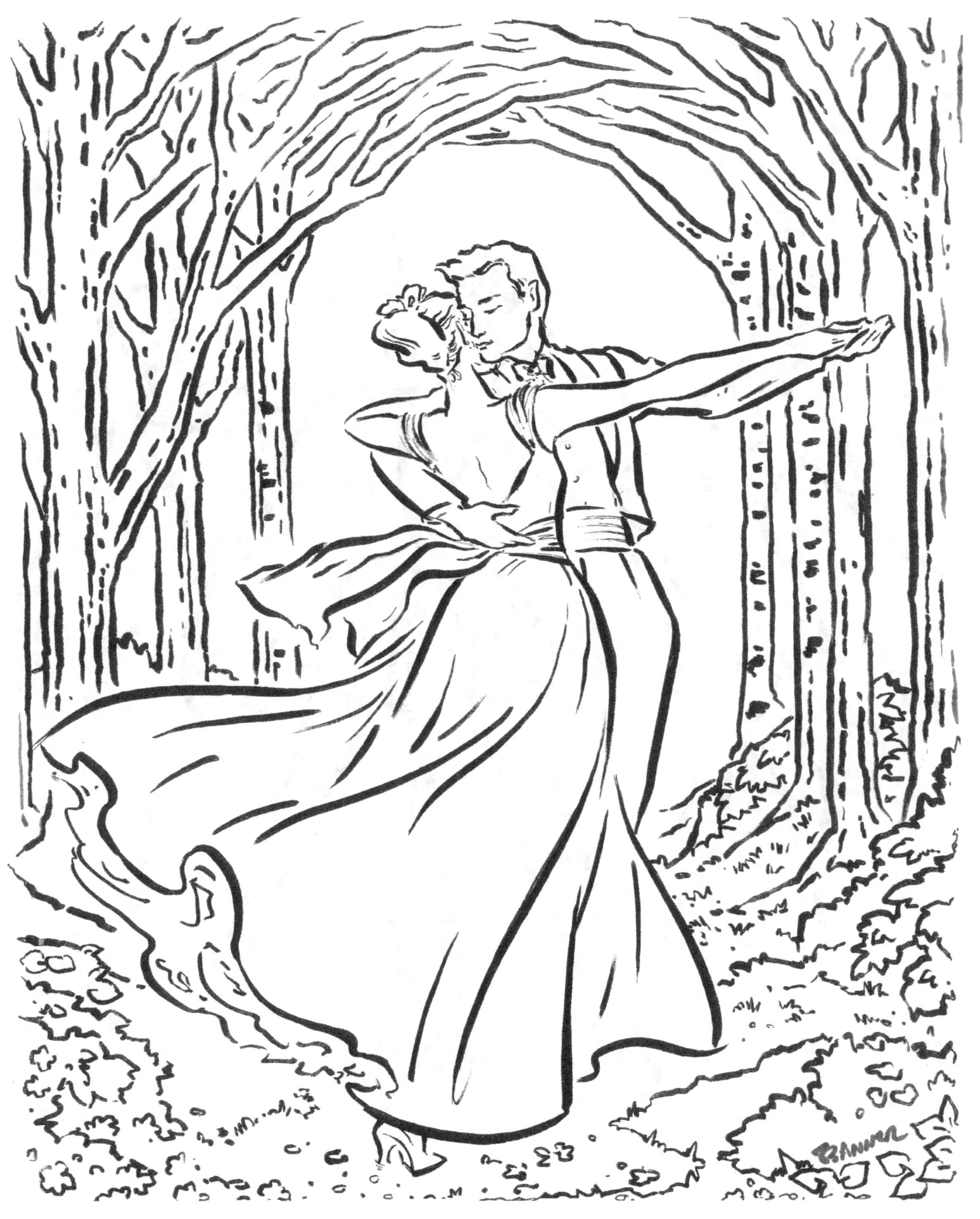

Viennese Memories

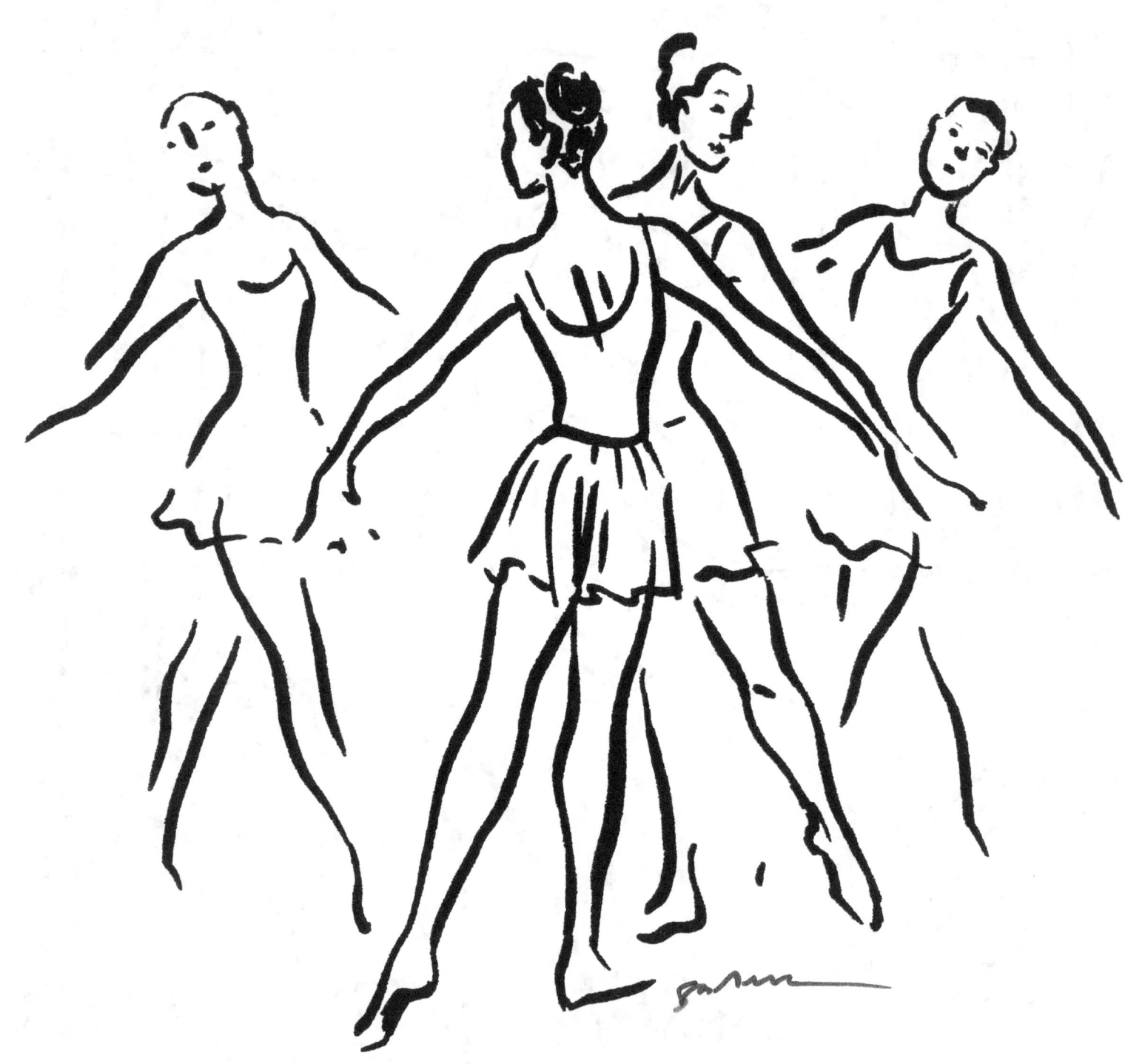

Bach Symmetry

'Guide to Strange Places' Opens at SPAC with Thunderous Fervor (Saratogian, July 2003)

"George Balanchine explores the inner structure of Bach's Double Violin Concerto in his architecturally brilliant Concert Barocco. More than 60 years after its premiere, Barocco is an aesthetic and intellectual gem, a master work of strength, logic and pristine beauty. Abi Stafford and Wendy Whelan embodied the voices of the two violins, dancing in counterpoint to a clean, well-rehearsed corps that moved like a kaleidoscope filled with chips of opal and pearl."

"In the second movement, James Fayette partnered Whelan with delicious tension, lifting her high and placing her decisively on one toe to punctuate the calligraphic line of the corps."

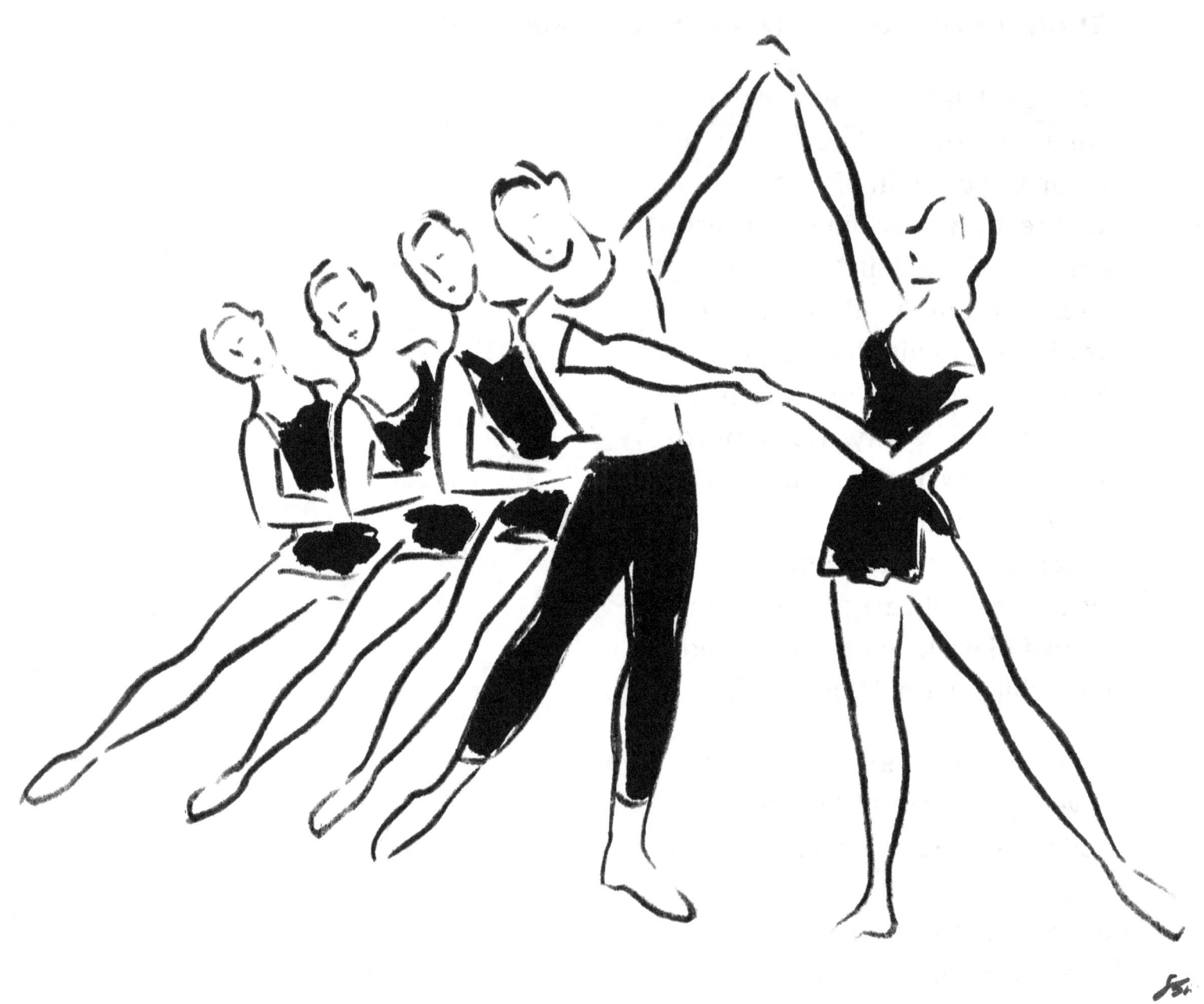

Quintet from Concerto Barocco

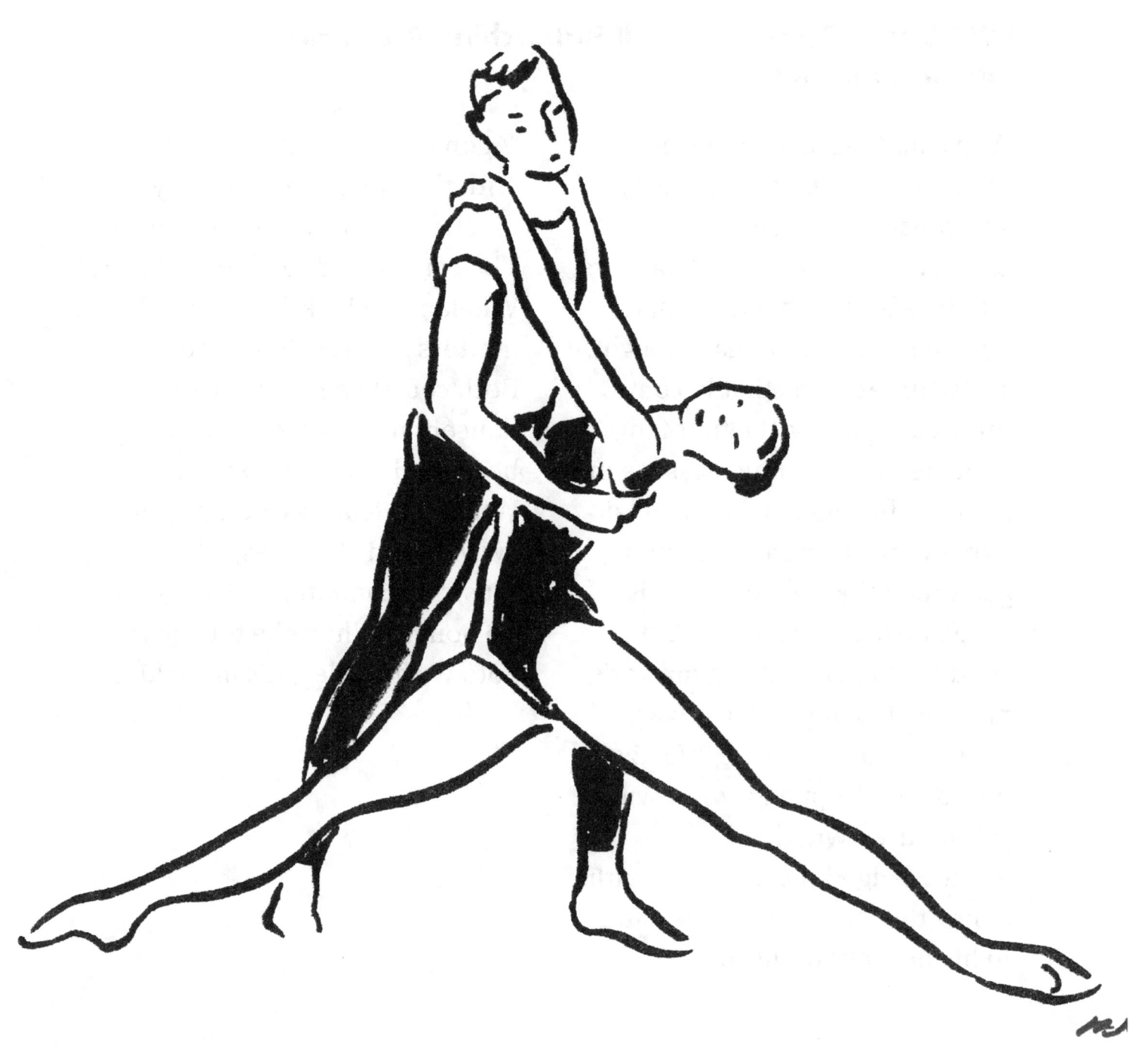

Duet I from Agon

NYC Ballet Opens With All-Balanchine Program
(Saratogian, July 2002)

"You could teach a math class with Agon. With perfect clarity and constant surprise, Balanchine assembles 12 dancers into brief, satisfying turns and tableaus: four, four against eight, sixes, threes, twos that become threes and finally, the first four, dancing their opening passage in retrograde. Damian Woetzel laid bare every measured step and gesture in this dance, which is based on sketches from a 17th century French dancing master's manual. Moving to the music of horns and a xylophone, Woetzel flexed and dropped a wrist with self-assured wit, then acknowledged the audience with a bow that spoke of his pleasure in his mastery of the art."

"Agon is a dance of great style, with the jumps and formally displayed arms of expert fencers. The central duet between Wendy Whelan and Jock Soto takes matters several steps further. Both courtly and carnal, the dancers performed delicate leg beats and extreme contortions. Whelan is fearless, doing splits, swivels and stretches, all musically smooth, as if she had no bones. When she touches Soto with her leg, it's like a kiss."

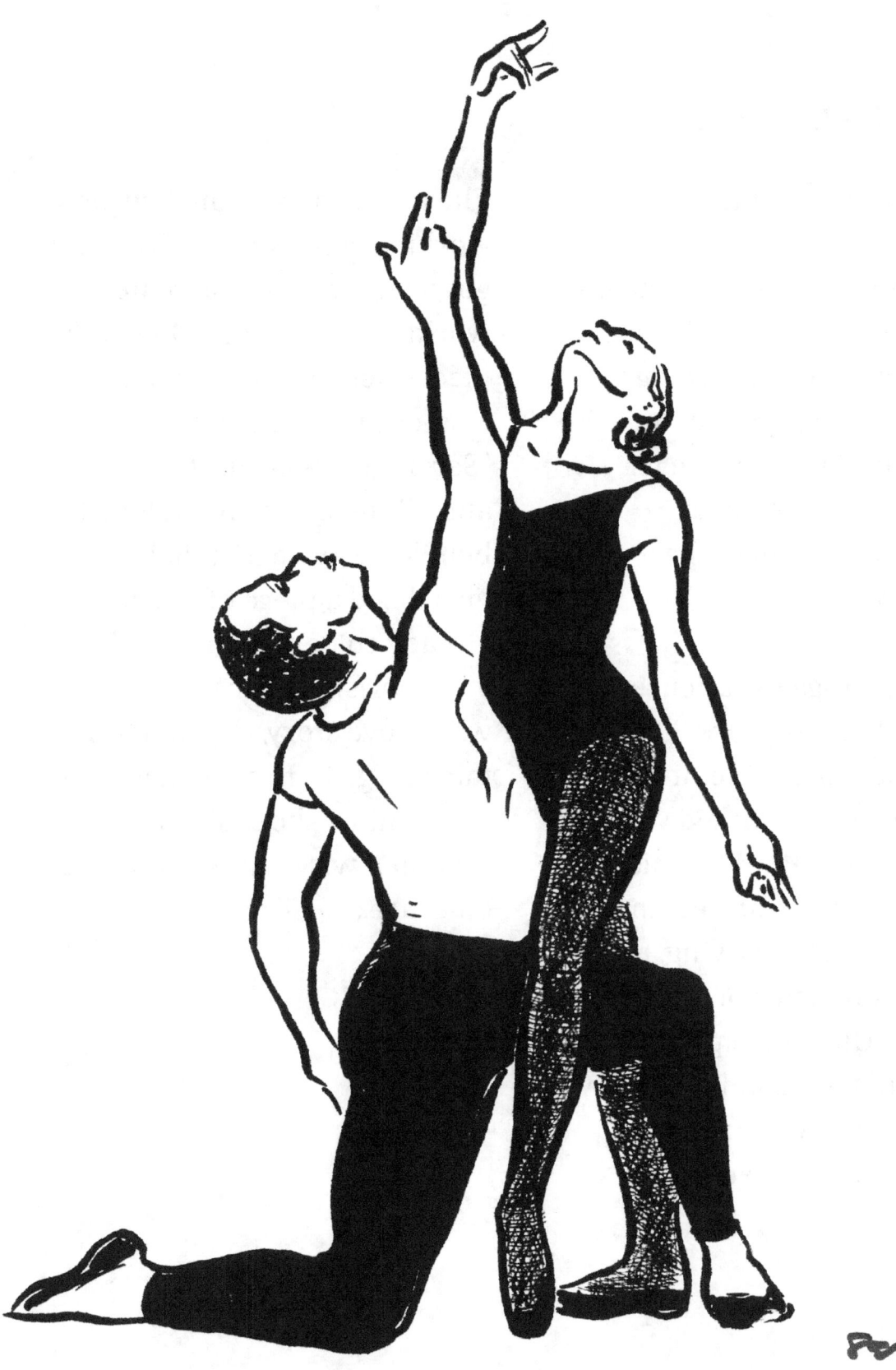

Duet II from Agon

Musings on Serenade

Serenade is woven into the fabric of my life.

In 1976, my mom took a teaching position at Skidmore College and moved our family to Saratoga during my senior year of high school. She came to town in September, the rest of us following at the end of that academic year.

My first Saratoga experience was playing in the New York State Summer School for the Arts Orchestra, which worked with members of the Philadelphia Orchestra and performed under the baton of Robert Irving, the principal conductor of the NYCB orchestra. One of the pieces we performed that summer was Tchaikovsky's "Serenade for Strings", which I loved...

The following season, I began working summers at SPAC, and got my first immersion into the world of Balanchine. One of the pieces performed that season was, as fate would have it, "Serenade". A beautiful dance, and all the more marvelous to behold because in it, Balanchine visualized a piece of music already so personally familiar and cherished. For me, the ballet was a love story, the romantic tale of a girl's first lost love, and the comfort she finds in her mother's wiser, understanding embrace...

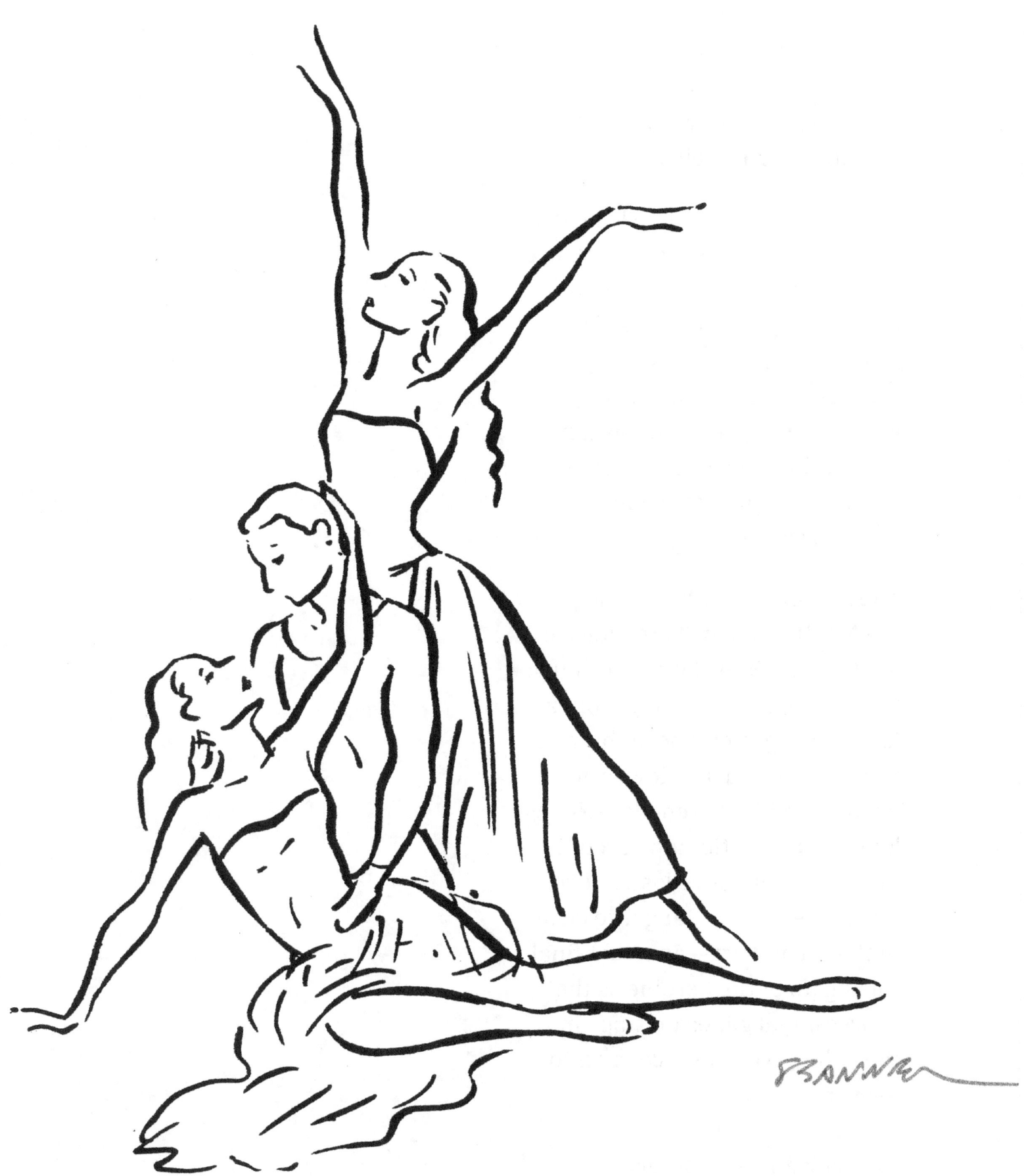

Serenade Trio

Serenade was always a favorite of my mother's as well.

For her, like me, the music made more beautiful through the dance Balanchine created for it. Years later, during my mother's final weeks at Saratoga Hospital, my brother said we should bring in recordings of the music she loved so much, Balanchine's music— we should play "Serenade" for her, and so we did.

The summer after her passing, the NYCB brought "Serenade" to SPAC once again. I went, as much for the connection to my mom as for myself, grateful be embraced by an old friend. But it was not my old familiar Serenade—No longer a romantic, adolescent tale of love and love lost, but so much deeper—the angel so clear in the second act—and that final raising up of the heroine as the processional glides up stage into the light—truly an ascension to heaven.

An elegy for my mother.

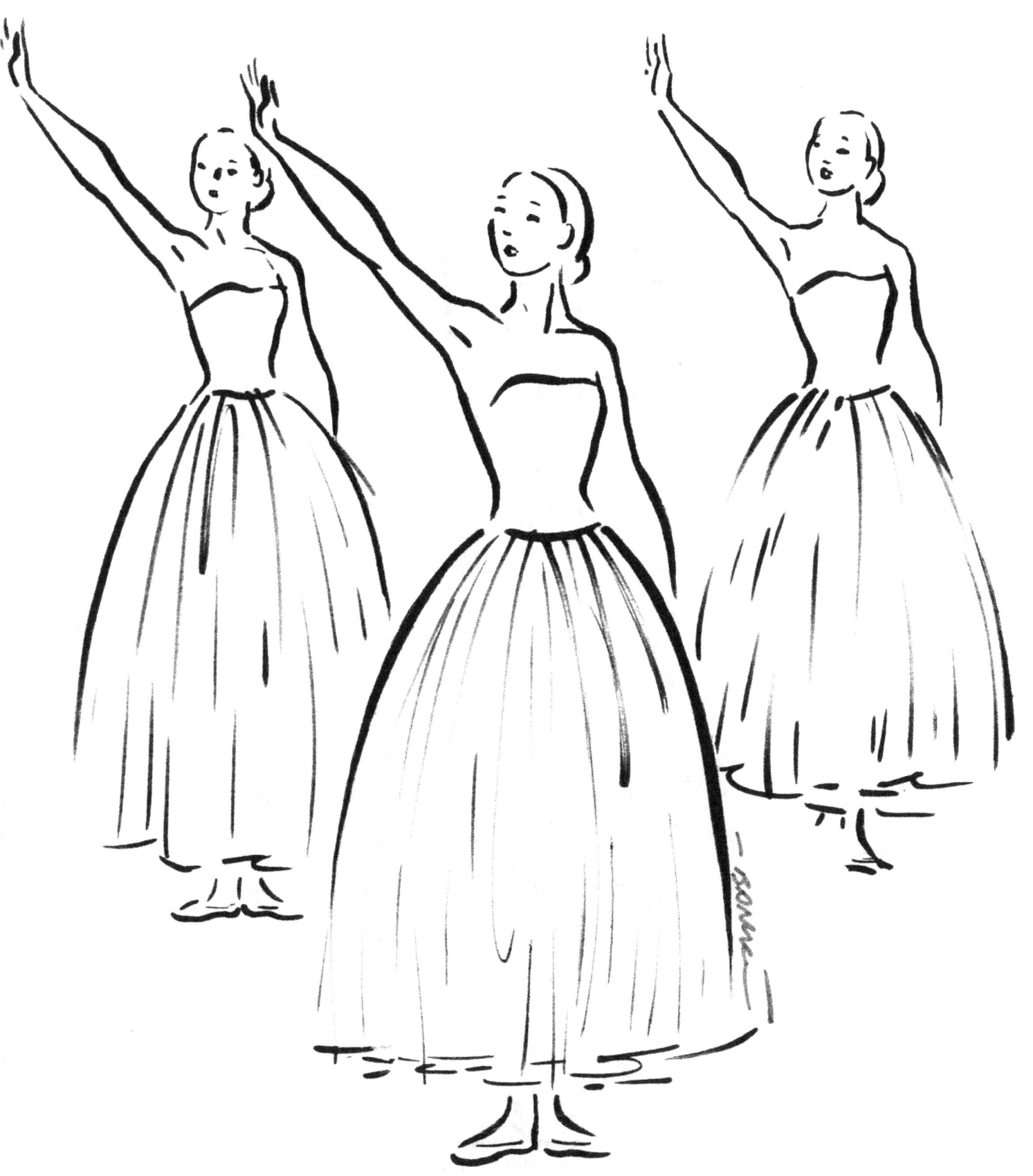

Farewell Serenade

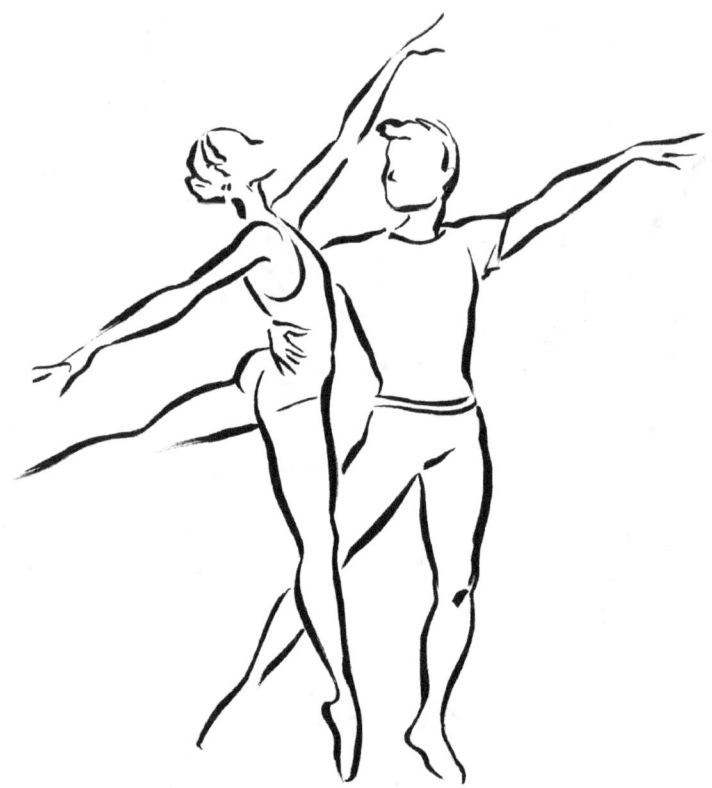

Saratoga Favorites, Mae & Shawn Banner
Copyright © 2015 by Shawn Banner
All rights reserved. Printed in the United States of America.

❈

No part of this book may be used or reproduced in any manner whatsoever
without written permission except in the case of
brief quotations embodied in critical articles and reviews.

❈

For additional information regarding this work, or to learn more about
Shawn Banner's illustration work, please visit
www.shawnbanner.com

❈

First Edition

www.ingramcontent.com/pod-product-compliance
Lightning Source LLC
Chambersburg PA
CBHW080851170526
45158CB00009B/2701